D1112660

Daughter, even after this book is read and set aside, I hope you will always remember...
all the thoughts and
wishes it holds inside.

ISBN: 978-1-68088-339-8

◤ and Blue Mountain Press are registered in U.S. Patent and Trademark Office. Certain trademarks are used under license.

Printed in China.
First Printing: 2020

♻ This book is printed on recycled paper.

This book is printed on paper that has been specially produced to be acid free (neutral pH) and contains no groundwood or unbleached pulp. It conforms with the requirements of the American National Standards Institute, Inc., so as to ensure that this book will last and be enjoyed by future generations.

Blue Mountain Arts, Inc.
P.O. Box 4549, Boulder, Colorado 80306

Daughter...

I Want You
to Know This

Douglas Pagels

Blue Mountain Press™
Boulder, Colorado

I know how it feels to love someone
with all my heart...

because that's how I love you.

You are — and you always will be — the most beautiful gift anyone has ever been given.

We never know how life will turn out... or what the years will bring. But I want you to remember this: of all the things I could have been, I will always be grateful beyond words... that I get to be the parent of the most wonderful girl in the whole world.

I get to be yours.

You are everything the word "beautiful" means to me, and I want to thank you for being such a precious and adorable daughter. You are so many lovely, exceptional things wrapped up in one very cherished person.

Beyond words that can even tell you how much, I hold you and your happiness within my heart each and every day.

Over the course of time, there have been so many changes in our lives and in everything around us. But one thing always stays the same: it's my sweet feeling that... you are more than just the brightest star in my sky.

You're one of the most special people in the whole wide world.

You're not just a tremendous daughter. You're a special, incredible, and one-of-a-kind person.

All the different facets of your life — the ones you reveal to the rest of the world and the ones known only to those you're close to — are so impressive.

And as people look even deeper, I know they can't help but see how wonderful you are inside.

I'll always love you,
Daughter, with all my heart.

And I couldn't be more proud
of you... if I tried.

It's hard to put into words how I feel about you.

But I wish I could capture those feelings each day. And if every day became a page and I put them all together... what an amazing book that would be. It would be a tribute about how much it means to me to have a daughter like you, and it would reflect all the things I hold in my heart.

An unbelievable amount of love would have to fit between the covers of that book, but I'd find a way to take all the memories and the feelings of hope and joy and just weave them all together.

And maybe no one would understand it except for the two of us, but I want you to know... it would be the best story ever.

Sometimes we need
reminders in our lives

...of how much people care.

If you ever get that feeling, I want you to remember this.

If I could be given any gift imaginable, one that would light up my life, make me happy forever, and make my days just shine... the gift I'd choose would be you.

All throughout my life, I have wished for the perfect words to tell you how proud I am of all you've done and everything you've become.

All throughout your life, you have amazed me and impressed me and given me thousands of reasons to love you more than I already do.

And I know that I could have hoped and prayed and dreamed all my life... and I could have wished on a million stars.

But I couldn't have been blessed with anyone more remarkable... than the daughter that you are.

We all have days when the happy, wonderful warmth of a hug... would make everything better.

Every time you need a hug and I'm not there to give it, hold on tight to the words in this book... and let them hug you right back.

I will hold you in my heart forever...

and I hope you'll always remember that.

Daughter, I think you are an absolute gem. And when I look at you, I see so much that is so wonderful to believe in. I want you to see that in you too. You are awesome in more ways than you know, and I'm willing to bet that you can do just about anything you set your mind to.

Put your wisdom and your heart into working for the things you want to achieve.

Stay positive and strong and proud of who you are. Remember that each new day is a blank page in the diary of your life, and your task is to turn that diary into the best story you possibly can.

Trust in new beginnings and have faith in happy endings... and always believe in you.

When you came into this world
and into my life…

so many wonderful things happened.

Although I was the one holding you, you were the one enfolding so many of my hopes and dreams. Although I was the one who was supposed to teach you all the things to do as you grew up, you were the one who taught me — constantly — of my capacity to love, to experience life in its most magical and meaningful way, and to open my heart wide enough to let more joyful feelings inside than I ever imagined anyone could have.

I love looking at photographs of you through the years. There are so many great ones! Each one tells a story, and every picture has the ability to take me back in time.

So many of the best treasures I'll ever have are those photos that show the sparkle in you... just being beautiful, amazing you. You're the one with the smiles that will always shine in those pictures.

And I'm the one with the smiles that will stay... forever in my heart.

Daughter, the memories we've made together are such magnificent gifts. And I just can't help but think: Someone else can win the lottery... and get all the prizes waiting to be won. Others can take their exotic travels, buy the homes of their dreams, and spend their entire lives adding to their worth.

I'm perfectly content to just smile and close my eyes and to lovingly realize that...

thanks to you...

I'm already the luckiest person on earth.

As your parent, I want to be a place you can come to… for shelter, for unconditional caring, and for sharing all the support I can give. I want to be a gentle heart you can turn to… for answers and understanding. I want to be there every time it would do your heart good to hear a joyful reminder of how incredibly special you are and what a light in my life you'll always be.

I want to do everything I possibly can for you... because that's what love does when it is strong and grateful and giving.

I want you to know what a gift it is to be your parent... and that my love for you is never-ending.

A special reminder of beautiful

things that are true about you...

No matter how crazy this world gets, don't ever forget the things that matter most. One of those incredibly important things... is your well-being: your health, your happiness, and your recognition of the fact that you are so wonderful and worthy and deserving...

Spend a part of every day remembering that you are you... and that you'll always be worth whatever it takes to bring a "yeah, I've got this" smile to your face.

Whenever you're feeling overlooked and underappreciated, brighten your life by gently saying this...

"I am aware that I may be less than some people prefer me to be, but most people are unaware that I am *so much more* than what they see."

As you journey along through life, remember these words every day: You were given the gift of being simply amazing.

And no one can ever take that away.

You are someone I love with every smile, every hope, every prayer, and every treasured memory within me.

When I look at you, I see someone who has so many paths yet to walk, opportunities to explore, and stars to keep on reaching for.

As the years go by, my hopes will travel beside you on all your journeys. My heart will still wish you sweet dreams at night.

And you will be a joy to me

…all of your life.

There are ten words I keep

in my heart every day...

And I want you to know that those words always bring me a smile, sometimes they have me blinking back tears, and they reflect an unbelievably sweet feeling that will always be closest and dearest to me.

Those ten words are...

"How blessed I am to have
 such a wonderful daughter."

We are family, and we know what love is.

We have memories that are golden, bonds that can't be broken, and years — woven together — that keep turning into our own beautiful forever.

What a gratifying thing it is to have you as my daughter... and to watch such a lovely person blossom and become all that you are today. You're someone I admire and adore with all my heart.

Thank you for enriching my life beyond belief. Thank you for the grace and the goodness, the hopes, the memories, and the happiness. Thank you for bringing so many priceless gifts to me.

There are things I could tell you every day and still not say often enough. But I want you to know that forever I will have a smile in my heart... that belongs to you.

Every time you see this book in the years ahead, I hope it will make *your* heart smile... just to know how much you're loved and what a blessing you are. And I hope you'll always
 remember this, too...

If I were given a chance to become anything I ever wanted, there's nothing I'd rather be than your parent.

And there's no one I'd rather have as my daughter… than you.

About the Author

Best-selling author and editor Douglas Pagels has inspired millions of readers with his insights and anthologies. His books have sold over 3.5 million copies, and he is one of the most quoted contemporary writers on social media and online today.

His writings have been translated into over a dozen languages due to their global appeal and inspiring outlook on life, and his audience has now increased even more — thanks to his very popular line of pix & pagels greeting cards, books, calendars, and gift items. Be sure to visit www.douglaspagels.com to find out more about the author and this wonderful, colorful, and one-of-a-kind collection.

If you have enjoyed this book, please spread the word. Giving it a positive recommendation online is greatly appreciated! And be sure to keep this book close in the months and years to come. It will always be good to visit again, and it will bring you smiles and warm your heart every time you do.